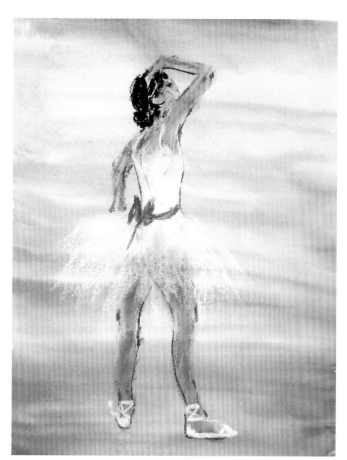

PASTELS

STYLES AND TECHNIQUES

This edition published in 2017
By SpiceBox™
12171 Horseshoe Way
Richmond, BC
Canada V7A 4V4

First published in 2010
Copyright © SpiceBox™ 2010
Text copyright © Philip Berrill 1996

ISBN 10: 1-77132-047-8
ISBN 13: 978-1-77132-047-4

CEO and Publisher: Ben Lotfi
Creative Director: Garett Chan
Art Director: Christine Covert
Designer: Leslie Irvine
Production: James Badger, Mell D'Clute
Sourcing: Janny Lam, Jin Xiong

For more SpiceBox products and information, visit our website:
www.spiceboxbooks.com

Manufactured in China

7 9 10 8 6

CONTENTS

INTRODUCTION

Have you ever stopped to watch someone create a picture with colored chalks on a sidewalk? Or had artists on the street offer to sketch your portrait? If so, chances are you have seen pastels in action.

Pastels are an accessible and easy-to-learn medium. Part of the joy of working with pastels is that they offer scope for the individual's freedom of expression and style.

Pastels lend themselves to the rendering of almost all subjects. They are robust and durable, especially if care is given to storing or framing the finished work. Pastels can be

very messy, but by taking the appropriate steps, pastel pictures can be produced with remarkably little fuss or mess. Pastels are an ideal medium to use at home, in a classroom or in an art studio because they require few supplies and are quick to clean up and store. The materials are very compact, making them convenient to carry with you outside on sketching and painting expeditions.

Pastels are an easy medium to learn to use, and by following the demonstrations outlined in this book, you will be able to catch the essence of a subject with just a few strokes of a pastel. You'll also be able to produce a preliminary sketch as the basis for a main picture as well as produce finished pastel pictures.

If you are a beginner, pastels are an excellent medium to start with. If you are a painter, but have not tried pastels, you will likely enjoy the experience when you try them. If you already use pastels, this book will introduce you to some new ideas and approaches to the medium and will help you develop your skills still further.

PASTEL MATERIALS AND EQUIPMENT

While pastels and paper are all you'll need to begin immediately, you will want to start adding materials to your collection over time that suit your own personal preference. The following description of pastel materials will give you a full understanding of what is available along with some other items you may want to add to your pastel supplies right away.

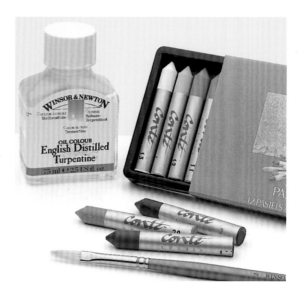

Soft Pastels

Soft pastels are made from a mixture of very fine pigment, chalk and pipe clay mixed with water. They do not deteriorate with age, and the finished painting will not crack, fade or darken over the years. Soft pastels usually come in round stick form, are soft and powdery, and are applied directly to the paper. Delightful effects can be achieved by gently rubbing one pastel color on top of another. Pastels can commonly be purchased individually or in sets of 12, 24 or 48.

Firm Pastels

Firm or hard pastels usually come in square stick form and are essential chalk-based and are ideal for pastel drawing, pastel sketching and detailed work where a firm confident line or detail is required.

These firmer pastels are less smudgy than soft round pastels, and while they can be blended by layering one color on top of another, they do not lend themselves so readily to blending with the finger. Picasso, Degas, Delacroix and many other great masters of the past century have used this type of pastel.

Pastel Pencils

Pastel pencils are firm or hard pastels encased in wood, in the same manner as the traditional graphite pencil. Pastel pencils are useful when you want to make more detailed studies but still want the velvety look of pastels.

The point of the pastel pencil can help give the detail more easily. Animal and bird studies, where the effects of fur and feather are important, are good examples of subjects often rendered in pastel pencil. Most artists collect together a mixture of soft and hard pastels as well as pastel pencils, as they can be intermixed.

Oil Pastels

These are quite a bit different from chalk-based pastels and should not be confused with them. Oil pastels are made from a combination of pigments, oils, and wax as a binding agent. They provide a sharper, more defined look, than the more powdery chalk pastels. They are more difficult to blend, but they also allow for other interesting techniques.

Pastel Paper

The soft and powdery nature of pastels means that they need a paper with a slight texture to enable the pastels to grip the surface. A paper with a smooth or shiny surface offers nothing for the pastels to adhere to. Some pastel techniques, especially the pastel sketching technique, allow the background color of the paper show through and thus become an integral part of the whole picture. For this reason, pastel paper comes in a wide range of colors and is produced by a wide range of art paper manufacturers. In pastel painting technique the whole surface of the paper is usually covered, which of course means that the color of the paper is less important. It is possible to use colored construction paper (the type used in children's crafts) for trying out ideas and pastel sketches. It is quite inexpensive and a pad usually has a range of colors to experiment with. However, for finished and important studies be sure to use proper pastel paper, otherwise the quality and color of the paper will deteriorate over time.

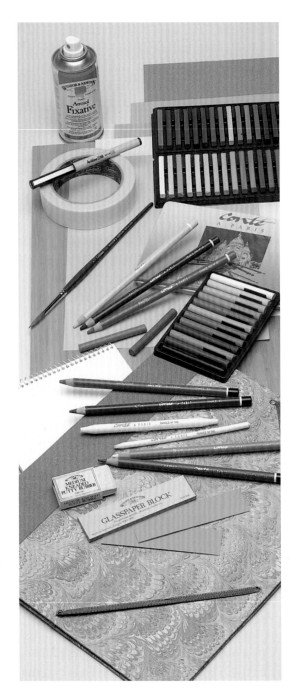

Pastel paper comes in sheet, sketchpad and sketchbook form. When you are purchasing paper, be sure to look carefully at the colors in the pad to ensure that they are colors you feel you will be comfortable working on. Try to ensure that your pastel paper is at least 60 lbs or above in weight. This will ensure that it is substantial enough for you to work on. An ideal weight is 80 lbs.

Erasers and a Brush

There will be occasions when you make a mistake, or you decide that you would like to change part of a picture. Don't try rubbing out the area with a normal eraser; the pastel will smudge and look unpleasant. To correct an error or to make a change, use a dry, round paintbrush with fairly stiff bristles. Gently jab at the area to be changed until it loosens and dislodges the surface pastel. Blow this away from the picture and then use a soft kneaded eraser to remove the remainder of the pastel. The area can then be reworked.

Fixative

When the pastel picture is finished there is always a risk of it being smudged accidentally. A clear fixative is often used to hold the loose particles of pastel to the surface of the picture. Fixative normally comes in aerosol cans and is very convenient to use in this form. It can also be obtained in bottle form with a tubular mouthpiece to apply a spray of fixative.

Alternatively, some artists prefer not to fix their pastel studies at all, as they believe the picture loses a little of its freshness. The choice is a personal one.

Drawing Board

Many people like to work flat on a table, while others prefer to stand and work at an easel. In either situation, you will require a rigid surface on which to work. The surface will need to withstand the firm pressure that you'll often be applying when you work with pastels. A compact, portable drawing board allows you a lot of versatility in working outside or in various locations. You may put a bulldog clip or a little masking tape along the edges of your paper to secure the loose end of the page you are working on so that it doesn't curl up.

If you take a page out of your sketchpad to work on, or buy paper by the sheet, it's especially important to have a good drawing board. These don't need to be expensive and can be obtained from most art supply stores. Drawing boards are made from laminated wood or white plastic covered chipboard.

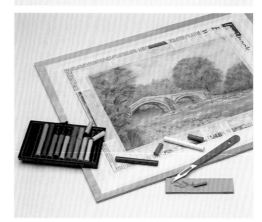

(top to bottom) Drawing board, drawing board with newspaper, and pastels with drawing board

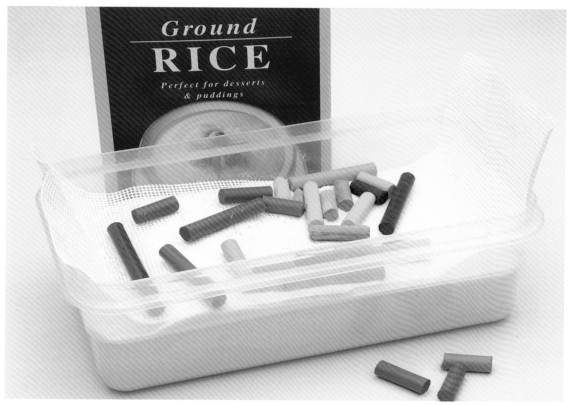

Loose pastels stored and kept clean in a plastic box of ground rice

Boxes and Care of the Pastels

Loose pastels can become soiled and grubby as color is transferred from the sides of one pastel to another in their box or with your fingers. A handy way to store pastels is in a shallow, plastic storage box with a press-on lid, approximately 9" x 6" x 3".

Line the box with a stiff piece of netting so that the sides come almost up to the top and half fill the box with ground rice.

If you place your soft pastels in the box on top of the netting, and then snap the lid on and lightly shake the box, the pastels will bury themselves in the ground rice, which will keep them clean. The sides of the netting can then be pulled upward to bring your pastels to the surface again.

Newspaper

For some artists, a drawing board can be too firm a surface to work on. The soft, cushion-like effect when using a pastel sketchpad can be quite pleasant. If you want to create the same cushion effect, lay several sheets of newspaper on your drawing board before fixing your sheet of pastel paper on top.

Portfolio

Pastel pictures should be kept clean and flat, ideally in a portfolio. To ensure that one pastel picture does not transfer color to the back of another one in the portfolio, I recommend that you cut a piece of greaseproof paper (wax paper or parchment) the same size as the picture. Use a paper clip at each corner to fix the protective greaseproof paper to the pastel study.

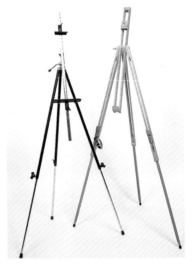

Easel

There are a number of different styles of easel, and the type you choose will largely depend on where you prefer to work. Table easels are inexpensive and versatile because they can be set at different angles and can be folded flat for storage. When you purchase an easel, test a few different models at the store to find one you like. Ensure that the one you choose can be positioned for working standing up or lowered to sit at (great for working outdoors), as well as adjusted to a flat table. It should be light enough to carry, yet rigid enough to work on, leaving both hands free to hold and work with the pastels.

Sundry Items

As you begin to work with your pastels more and more, you may find there are a few other items you may want to pick up at an art supply store. A 2B pencil, a fine, black felt-tip or nylon-tip pen, a stick of charcoal and a small sketchbook for notes, ideas and practice are all items you will find useful to keep with you. A small block of fine grit sandpaper and a craft knife will assist in shaping the ends of your pastels.

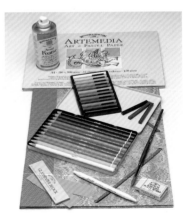

You may also want to keep an eye open for a carry bag with compartments for the additional materials you start to acquire, and a portfolio for storing your completed art.

The best way to figure out how pastels work is to play with them and see how many effects you can create. Take a brown round or square pastel, snap it into three pieces of differing length: short, medium and long. Take the medium piece between your thumb and forefinger and with the top edge of the pastel make long, medium and short downward strokes on a cream or light-colored pastel paper. Try hatching, a technique that involves making a series of parallel lines. Try crosshatching, where you make hatching lines and then cross other parallel lines over the original lines in a different direction. Jab the pastel at the paper to create dots, otherwise known as stippling.

Hold the pastel so that the long side of the pastel is touching the paper. Pull the pastel down the paper. Make long, medium and short side strokes. Now do that again with a lot of pressure from your hand and fingers on the pastel. The tone of the pastel stroke will be quite dark. Carry on down the page using a little less pressure, which should give a medium tone.

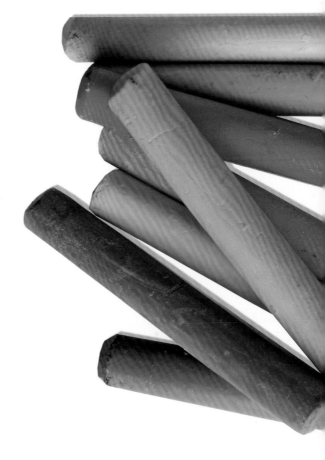

PASTEL MARKS AND EFFECTS

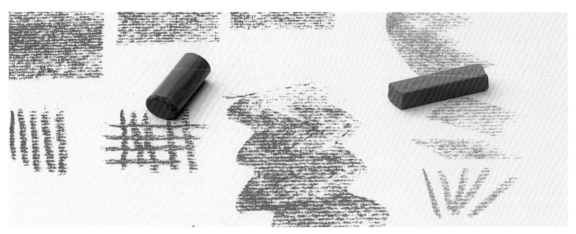

Shaping Pastels

Pastels come in varying degrees of softness or firmness, depending on the manufacturer, from very soft to quite hard.

Using a craft knife, you can carefully shape round and square pastels to a point, or to a chisel-edge. Sandpaper can be used to help shape a pastel end, or to resharpen the right-angled edges of the sides of a square pastel if they are worn away with use. Experiment with the top edges, sides and shaped ends of your pastels to create different effects.

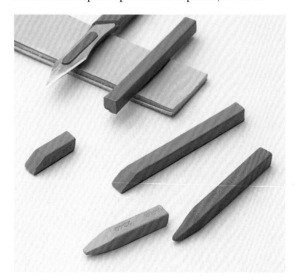

Square pastels - end you can shape

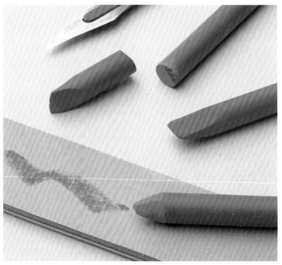

Round pastels - flat and pointed end

USING BLACK AND WHITE PASTELS

Dramatic and wonderful pastel effects can be created with the minimum of materials. Here we look at the use of white and black pastel on gray paper. Use white to identify the highlights and black to identify the darkest shadows. The gray paper acts as the medium, or third tone.

Right. Take a piece of white pastel and draw the wineglass shown here.

Below. Now draw the glass again, putting in the white highlights, then add the black pastel. Likewise try the saucepan, the shiny metal bowl and spoon, then the candle and candlestick holder. Don't let the black and white pastel mix on the paper when trying this demonstration or the resulting color will be gray. Look around your home for similar articles such as teapots or coffee pots, cups and saucers, mugs or ornaments you could try to sketch using this technique.

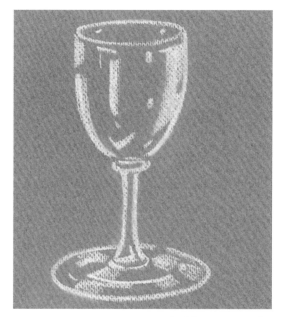

A white on gray study

HELPFUL HINT:

Have a strong source of light shining on the objects from the left or right. This will help emphasize the highlights and strong shadows.

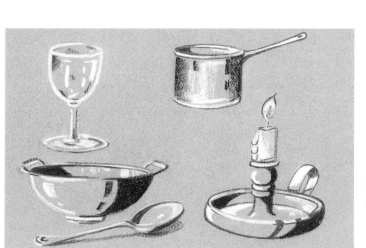

Black and white
pastel studies

STILL LIFE IN BLACK AND WHITE

Still life compositions can be striking when done with the black and white pastels on gray paper. The group shown here consists of a wine bottle, wineglass and bowl of fruit set against a drape and standing on a checked tablecloth.

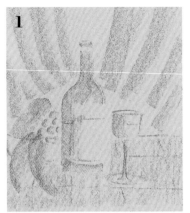

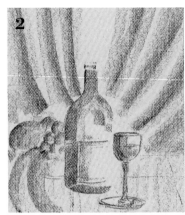

Stage 1. Begin by sketching the subject in light outline with white pastel, or a 2B pencil. This ensures the subject is correctly drawn and provides a sound foundation for your picture. Use the side and top edge of your pastel to shape the objects. Using the side of your black pastel, lightly add the tone of each item you see, including the background drape and the tablecloth.

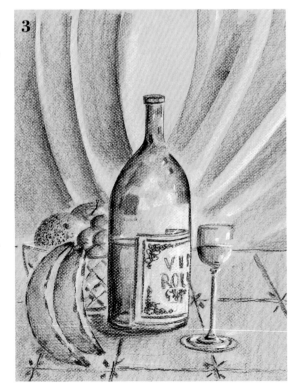

Stage 2. The light is coming from the right side. The darker tones and shadows will be on the left of the objects. Using a little extra pressure on your pastel, add the medium tones to those areas.

Stage 3. Still using the side of the pastel, add the darker tones to the drape and wine bottle. Now use the side and tip of the white pastel to add the highlights. Finally use the top edge of your black pastel to draw in the line and details of the fruit. Use stippling (dots) to create the effect of the orange skin. Add the line and details to the glass bowl, wine bottle, wineglass and tablecloth.

LANDSCAPE IN BLACK AND WHITE

The next lesson is a simple landscape. The subject consists of a pathway leading to a cottage, with trees to the right and distant trees, a lake and hills beyond the cottage.

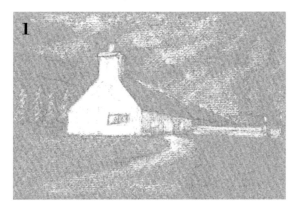

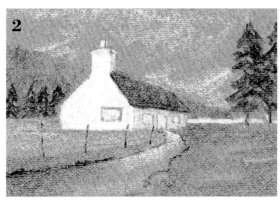

Stage 1. Sketch the subject with a 2B pencil. Using the side of a piece of white pastel, sketch in the white of the sky, sunlit lake, highlights on the trees, cottage, fields, fence and path.

Stage 2. Using a piece of black pastel, add the dark and medium tones to the hills, trees, roof, path, fields and fence.

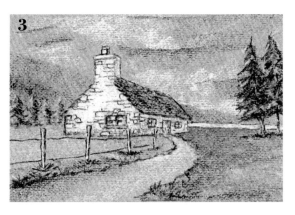

Stage 3. With the top edge of your black pastel, or top corner of a square black pastel, pick out the detail of the stonework on the cottage, right-hand trees, path and fence.

As you practice, you'll notice how much control and dexterity you are beginning to achieve using just the black and white pastels. This work provides an excellent foundation for your future pastel sketching and painting.

HELPFUL HINT:

With landscape subjects, paths, roadways, hedges, rustic walls and fences can be useful to help lead people's eyes into the picture.

VENETIAN BRIDGE

Stages 1, 2, 3 and 4. With the pastel sketching technique, the color of the paper used can play an important role in the overall look of the picture. Here, a cream pastel paper with a sanguine, reddish-brown, square pastel gives a vintage look to the work. Hold a medium-sized piece of the pastel with its side flat to the paper, and in the center of the page, make a sweeping upward curve for the underside of the bridge. Add the softer tones to the left and the right of the bridge opening and the darker stone slabs of the top of the bridge. With downward strokes add the first tones of the buildings and with angled strokes add the canal walls.

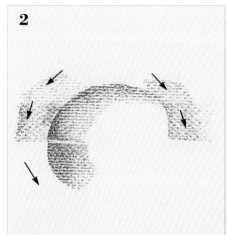

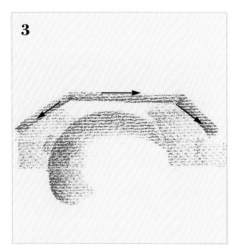

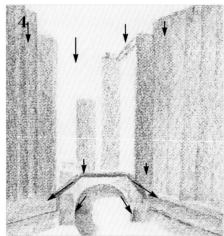

Stage 5. Continuing with the side of the pastel, but with a little extra pressure and with shorter strokes, add the start of the windows and shutters. Using the top edge of the pastel, pick out the more distant windows, the edges of the roof tiles and the lines denoting the stone slabs on top of the canal walls. Take great care not to let the side of your hand, wrist or shirt sleeve catch and smudge the surface of your pastel picture.

With the top edge of the pastel, add the lines and detail to the windows and shutters, church, bridge railings and canal walls. Finally, add a few sweeping lines on the canal walls and the bridge.

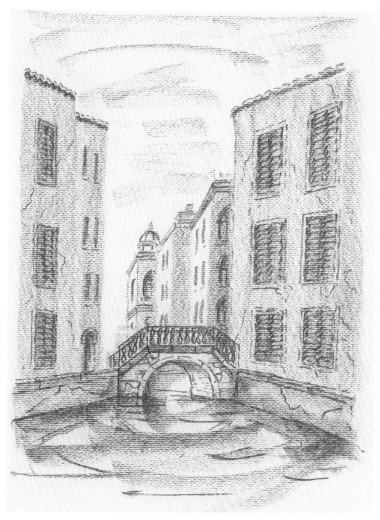

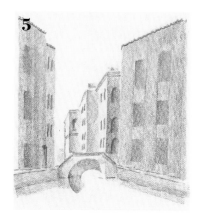

A DOORWAY

Now that you've practiced creating monochromatic pictures, it's time to begin using some colored pastels. Doors and entrances often make excellent subjects.

Stage 1. Use a piece of white pastel to block in the main shape of the door, doorstep, pavement and potted plant.

Stage 2. With the side of a piece of yellow pastel block in the front door. With the side of a piece of white pastel, hint at the white painted wall. Using a gray pastel and a ruler add the gray lines on the door and a hint of gray in the glass window above the door. With green and brown, block in the potted plants. Use a gray pastel on its side to block in the path.

Stage 3. Use the top edge of a black pastel just to outline the top overhang of the door, the detail in the windows and the overhang supports to the left and right of the door. Use a ruler and a dark brown pastel to carefully add the lines for the four door panels. Pick out the outline of the step in gray. Use a little black to suggest the edges of the paving stones. Pick out the darker green and darker browns of the plants and pots. Finally, add the door knocker, mail slot and door handle.

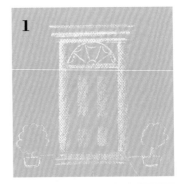

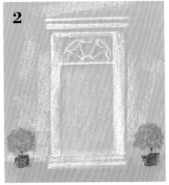

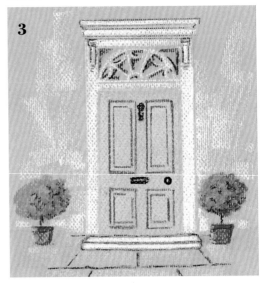

SUNFLOWER

Pastels allow artists to produce very delicate or very bold work and give freedom for individual styles. In this demonstration black pastel paper allows the yellow, brown and green of a sunflower to appear even more striking.

Stage 1. Draw the sunflower outline in yellow pastel. The leaves and stem should be drawn in green.

Stage 2. Fill in the petals with yellow. On this occasion the black outlines add to the very dramatic style of the picture. Put a little green on the central circle, then stipple reddish brown and black pastel to develop the striking center of the flower. Use a light and medium green for the leaves and stem.

Stage 3. The leaves and stem can have the line and detail added with yellow and black pastel. The sunflower can simply be left with the contrasting black background or a background of your choosing can be added. I have put in the blue sky. Be adventurous, experiment and play with ideas and images.

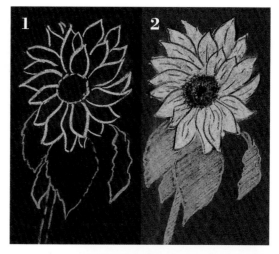

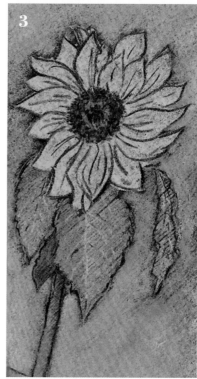

POINTILLISM

Georges Seurat, the French artist, developed a technique of painting pictures using small dots of color. This technique became known as pointillism. In this demonstration a candle and candlestick holder are used to practice this technique.

Stage 1. Sketch the subject out lightly using white pastel.

Stage 2. Stipple the white candle, white with dots of gray in the areas away from the flame. Using first yellow, then orange, then red and then mauve pastel, stipple the candlestick holder and candle flame in the way shown in the detail panel. Use white, then yellow for the highlights, then pale and dark blue for the color of the background drape and its shadows.

Stage 3. Use yellow, light green and dark green for the tablecloth. Use dark green and black dots under the base of the candlestick holder.

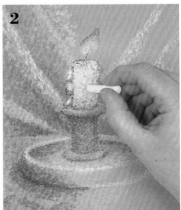

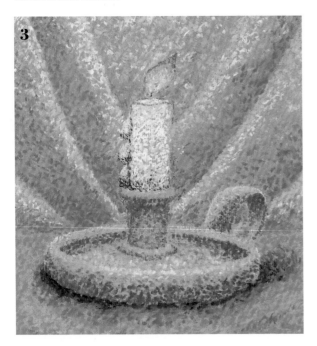

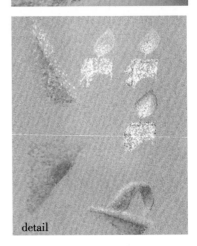

detail

STILL LIFE—COLOR

As you know, with pastel sketching, the pastel is not rubbed and blended with the finger as it is in pastel painting. It is applied directly to the paper surface and the background color is allowed to show through to become an integral part of the finished work. Here is an opportunity to use an exciting range of colors and try the pastel sketching technique on the same still life subject we used in the fourth demonstration, when only black and white pastels were used.

The subject is a bowl of fruit, a wine bottle and a wineglass on a blue checked tablecloth with a pinkish mauve drape in the background. The lines of the folds of the hanging drape and the perspective lines of the tablecloth lead our eyes from all four corners of the picture to our main subject on the table. The bottle gives height to the composition, while the bowl of fruit slightly to one side and behind the bottle and the overhanging bananas helps to add depth. There is a lively color interest. The light source is coming from the right-hand side.

Stage 1. Use a warm gray pastel paper and sketch the subject out with a piece of white pastel. Try to ensure that the bottle and wineglass are vertical and do not lean to one side or the other. This can be checked by turning the sketch upside down. Any leaning lines can be checked and corrected very simply.

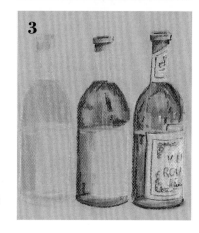

Stage 2. To ensure that you do not smudge what you are sketching, work from top to bottom, left to right if you are right-handed. If you are left-handed, work from top to bottom, right to left. Snap a piece of pale pink pastel, side on, to lay in the shadow areas of the folds in the drape. The highlights on the drape can be picked out with pale pink.

Stage 3. Using medium green, yellow, white and black, build up the wine bottle in the three stages shown. Apply the medium green, then pick out the yellowish green. For the very dark green area, use green superimposed with black. Use white to

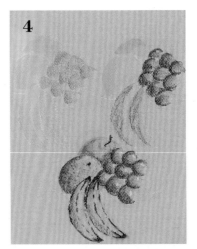

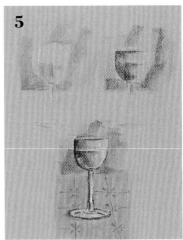

pick out the highlights. Using white and medium gray pick out the label shapes. The label details can be added with red, green and black.

Stage 4. The fruit in the glass bowl and the wineglass can be built up in a similar manner. With the fruit, watch especially for the stippling; that is, dotting of the pastel on the orange skin, the dark black ends to the banana, the rich dark shadow and the highlights on the grapes.

Stage 5. When building up the wineglass, the darker red of the wine is made by superimposing black on red. Also emphasize the darkest parts of the wineglass and the sharp white highlights. Finally, add the checked tablecloth, using pale blue for the cloth with a darker blue to draw in the lines of the pattern.

HELPFUL HINT:

Turn your sketch upside down to check your lines. Lines that are leaning or slanting are easier to see and correct when you look at your sketch upside down.

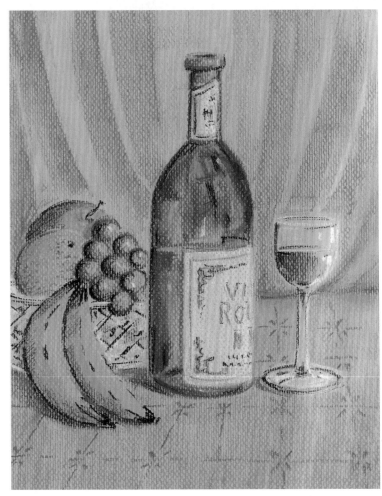

A COLOR LANDSCAPE

Landscape subjects provide good material for the pastel artist. The versatility of pastels enables one to capture the changing seasons of spring, summer, autumn and winter. We are surrounded by a wealth of differing landscapes—from gentle atmospheric landscape to the bright colorfulness of a sunset, from a snow-covered landscape to green fields and trees on a warm summer afternoon.

Using the pastel sketching technique, you can create a landscape sketch in color on a bluish-gray pastel paper.

Stage 1. You can either choose to lightly sketch out the subject in white pastel, or to work freehand, putting the sky in first and then building up the landscape.

Stage 2. Using the sides of white, then light blue and dark blue pastels, create the sky, leaving parts of the paper showing through.

Stage 3. With the tips of light and medium green pastels and a reddish brown for the copper beech tree, block in the first stages of light and dark for the trees and bushes. Using medium green, light blue and white pastels with sideways sweeping pastel strokes, start the river, remembering again to leave parts of the paper showing.

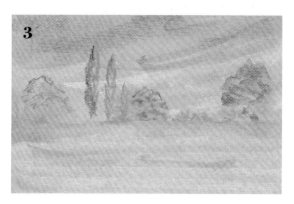

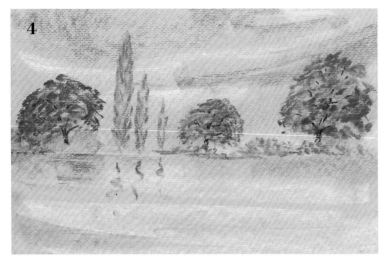

Stage 4. With a darker green, pick out the darker tones of the green tree foliage and bushes. Use a darker brown for the copper beech tree foliage and tree trunks. With a dark green and reddish-brown, hint at the reflections of the tall, slim poplar trees and beech tree.

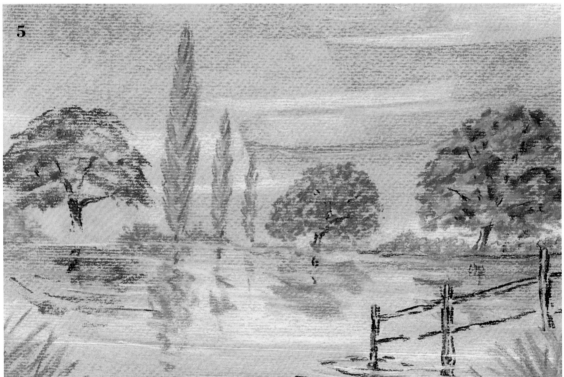

Stage 5. Using the top edge of your pastels complete the tree reflections in the river and add the white highlights on the water. Use a stick of green pastel to draw in the grasses in the foreground corners of the picture. With light brown, dark brown and white draw in the fence entering the river from the left-hand bank.

A SEASCAPE

Anyone who has stood close to the seashore will almost certainly have been moved and inspired by the sounds and color of crashing, swirling water. It can be a dramatic subject.

Stage 1. Sketch out the subject with white pastel.

Stage 2. Use white and light blue for the main sky. Superimpose a little dark blue on the darker clouds to the left and right. Ensure the horizon is quite light. Use pale blue and white for the distant sea and waves beyond the rock. Start the rocks with a cream and a medium brown pastel.

Stage 3. Add a darker brown and then a little black pastel to the rocks. Use light and dark blue, a little black and then white to create the swirling, wavy foreground sea.

Stage 4. The line and detail of the rocks are picked out with the side and tip of a black pastel. The effect of the white sea foam splashing upward behind the right-hand rocks is created by stippling with a white pastel. The white crests of the foreground waves are also added with a white pastel.

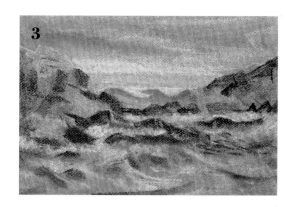

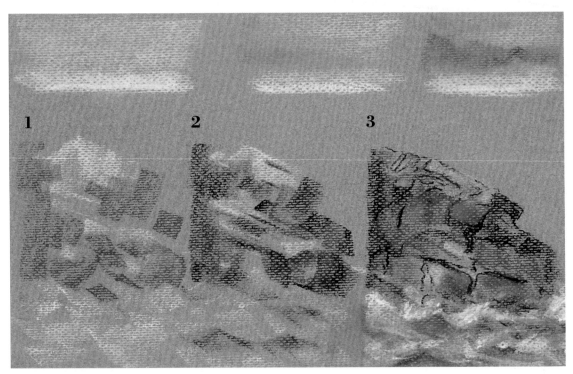

1 **2** **3**

detail

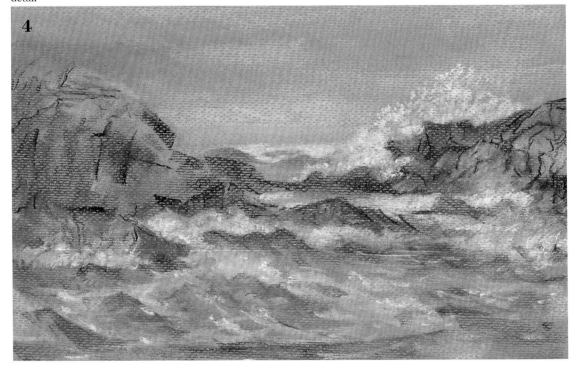

4

PASTEL PAINTING

The demonstrations so far have concentrated on pastel sketching. The art of pastel painting enables you to use your fingers to smudge and blend the pastels, one on top of the other. Pastel sketching uses the color of the paper as a feature of the sketch. In pastel painting the pastel obliterates the color of the paper. The blue ball clearly demonstrates the pastel painting technique.

Stage 1. Draw the ball outline in white pastel. Pick up your pastels and place light blue, medium blue and dark blue as in the areas shown in the demonstration.

Stage 2. Gently rub and blend the patches of pastel color together using the tip of a clean finger.

Stage 3. Add the yellow and orange background, blending them with your finger. Add the shadow on the table with a little dark brown and black.

Your fingers will become quite messy with color from the pastels, so remember to have a clean, damp cloth in a plastic bag handy; this will enable you to keep wiping your fingers clean. Mistakes can be removed, and corrections made, by gently jabbing at the surface of the paper with a clean, dry brush to dislodge the loose pastel, which you'll then blow off the picture surface. A clean putty eraser can be used to rub away the remaining area of color, thus avoiding the pastel smearing.

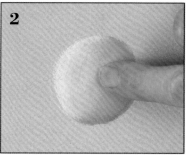

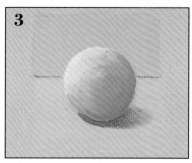

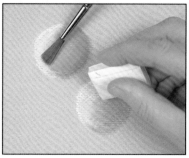

How to brush and then rub away pastel

A VALLEY LANDSCAPE

This landscape provides a very good subject to help you quickly understand the technique of blending pastels.

Stage 1. Sketch out the landscape using white pastel on a medium gray paper.

Stage 2. Using pieces of pastel on their sides, pastel in bold strokes of white, medium blue and dark blue for the sky. They may be strokes of different length. Lay on the paper sweeping side strokes of gray, blue and mauve for the hills. Apply light, sweeping side strokes of medium yellow, light green and medium green pastel for the fields. Using light pressure, superimpose a few white strokes on the green fields, just to give a hint of white. Add darker green patches of pastel on the tree and bush areas. Be generous with the pastel—put lots on the paper.

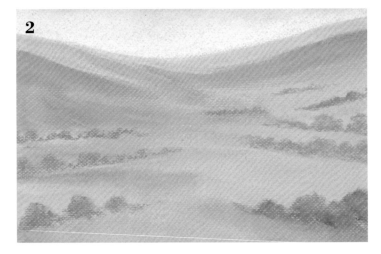

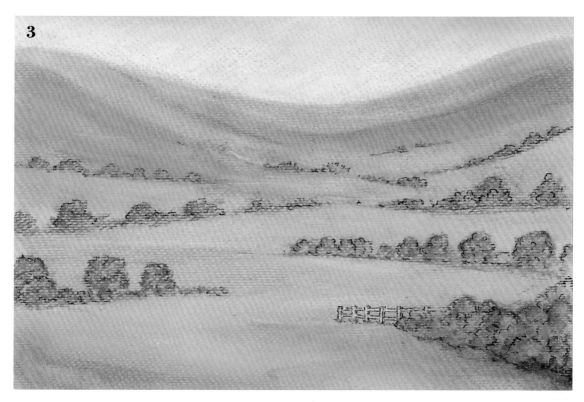

3

Stage 3. Go in turn to the sky, hills and fields and gently rub and blend the areas of color with a fingertip. Rub and blend the bushes and trees after the blending of the field areas. Gradually the color will obliterate the background color of the paper. A smoother look, quite different to that seen in the pastel sketching technique, should now be observed.

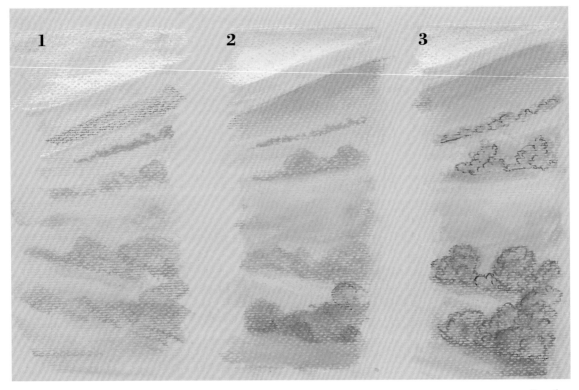

Detail

In the detail panel you will see the build-up of stages 1 and 2. In that panel you'll also see how to use a darker green and the top edge of a round or square black pastel or a black pastel pencil to emphasize the line, form and bushiness of the trees and foliage.

SNOW SCENE

Those who live in areas that receive snowfall enjoy one of nature's great events. The familiar landscape is blanketed in white. When the snow has fallen, there is a unique silence which gives the landscape its own special atmosphere. The mauvish-blue and gray shadows play on the white snowscape. Such views offer the artist very special opportunities.

Stage 1. Sketch out the subject with white pastel on a dark gray paper.

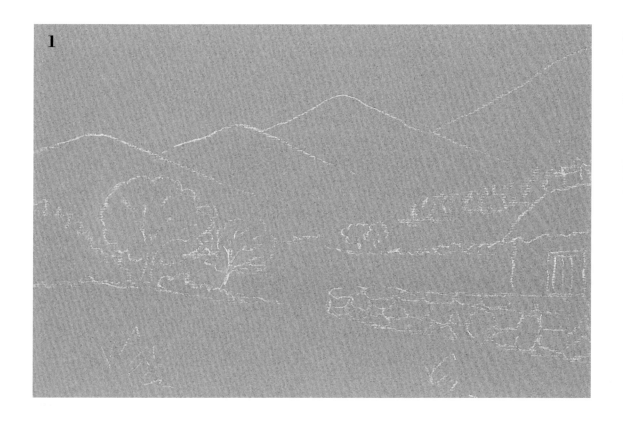

Stage 2A. *(left-hand side)* Lay on broad, sweeping strokes of white and blue pastel for the sky. Use blue, white and gray pastel for the snow-covered mountains and fields. Use white and gray pastel with a patch of vivid green for the fir trees on the left-hand side.

Stage 2B. Rub and blend gently the pastel with your fingertip to create the blended effect seen here.

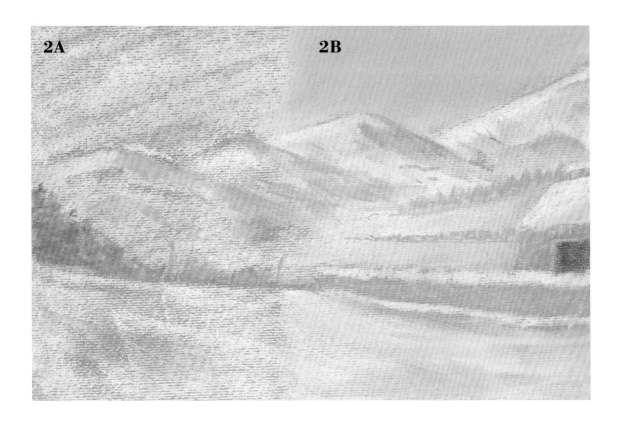

Stage 3. For the central areas use a sharpened black pastel, or a black pastel pencil, and the top edge of a brown pastel to pick out the detail of the trees, stone wall, barn and the grasses which peek through the foreground snow.

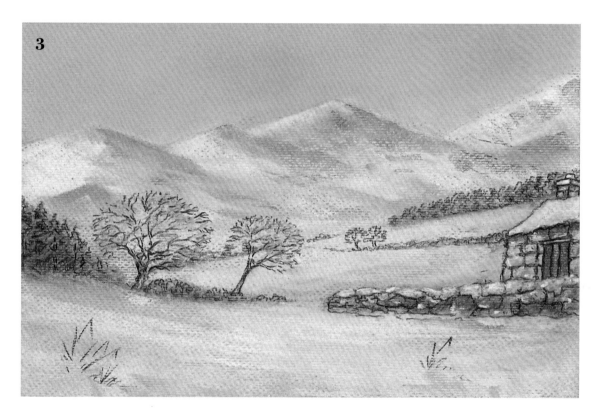

HELPFUL HINT:

Because of the speed with which you can work with pastels, they are excellent for outdoor sketching in cold weather. The sketches can provide useful material for indoor painting in any medium.

ALBERT TOWER

The Isle of Man sits in the Irish Sea midway between Great Britain and Ireland. The Albert Tower was built on high ground overlooking Ramsey Bay. This unique piece of Victorian architecture now houses high technology broadcasting aerials and equipment, proving that conservation and technology can go hand in hand.

Stage 1. Sketch out the subject in white pastel.

Stage 2. Block in the main areas of pastel colors for the sky using white, a little light blue and gray. Block in the mountains, hillside and foreground fields, using pale yellowish-greens superimposed with darker greens. Use and emphasize the brownish-black mix on the shaded left-hand side of the mountains. Block in the light and medium dabs of gray to suggest the stonework for the tower. Add the reddish-browns and beige for the featured stonework on the main tower and for the wood of the door.

Stage 3. Add the stronger medium and darker green tones to the trees and to the foreground grass. Use a black pastel pencil to pick out the detail to the stonework of the tower, wall and trees and foreground grass.

HELPFUL HINT:

If sketching outdoors, spend 10 to 15 minutes walking around your chosen view or subject. Don't just take the first viewpoint that catches your eye, because you may find an even better one.

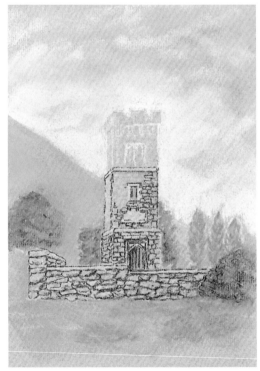

Detail

2

3

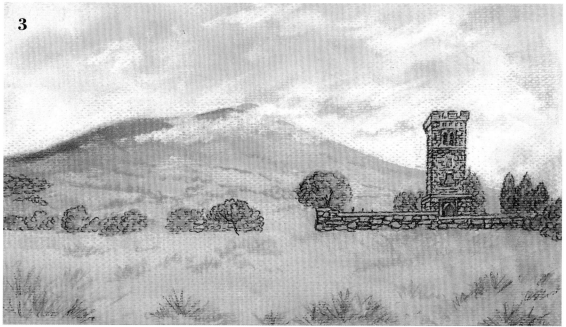

FRUIT AND VEGETABLES

The French painter Cézanne once said that all the problems in painting were to be found in a bowl of apples. He drew and painted lots of them. Fruit and vegetables can provide a wealth of material, both for pastel sketching and pastel painting with great diversity of color and surface texture. When next visiting a grocer or department store, look and think for a moment about how you could create pictures from the items you see. It might be a study of a single apple, a selection spread on a table or a more complex grouping.

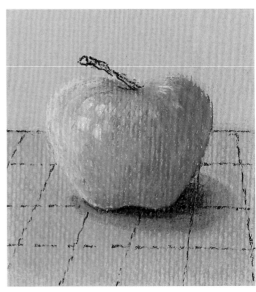

Apple

Mushrooms, tomatoes and carrots

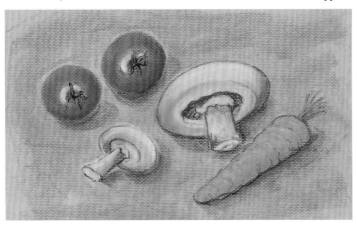

HELPFUL HINT:

When painting fruit, vegetables or flowers you're going to work with over more than one day, carefully wrap the subjects in bags and place them in the refrigerator. They will retain their freshness longer.

NARCISSUS

In an earlier demonstration a bold, free-flowing style of pastel sketching was used for the sunflower. In this demonstration a gentler pastel painting technique is explored to give a more photographic look.

Stage 1. Let the background paper provide the background color for the flower. Draw the outline shape in white on black paper.

Stage 2. Apply white and pale cream pastel for the petals, yellow and orange pastel for the center, medium and light green for the leaf.

Stage 3. Blend the larger areas with a fingertip and the smaller areas with a tortillon or a stub. Apply a dark brown pastel very lightly, then blend the shadows. Use a black pastel pencil for the darker shades and key lines. Use a black pastel gently on the green, then blend it for the darker green shadows on the stem and back of the leaf.

Be prepared for an intriguing surprise when painting potted plants or cut flowers. They will change and alter before your eyes as you paint them. Flowers are living organisms. The time of day, changing light and warmth of the environment affects them, just as those conditions affect us.

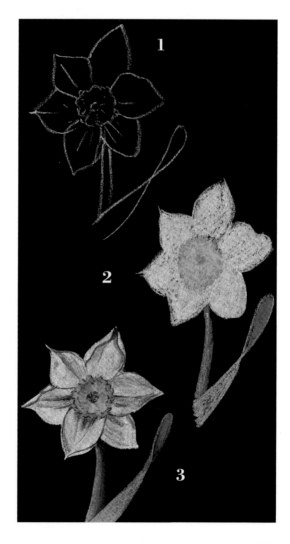

LICORICE ALLSORTS

If ever there was a subject made for pastels, especially the square pastel, it must be licorice allsorts candy. Open a box, scatter a few on a sheet of paper on the table in front of you and you have a subject in seconds. The square allsorts can be drawn in minutes using the wide side and narrow top edge of a square pastel. The blue and pink allsorts toward the front of the picture shown can be captured with stippling. The larger, round allsorts can be created in the pastel painting technique. For the table, use light and medium blue pastels, with black for the shadows. When you're finished you can enjoy the picture and eat the allsorts.

Detail

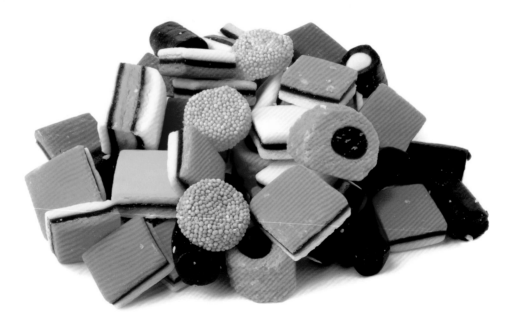

WATERCOLOR PAPER

Although pastel paper is normally colored, it is also available in white. Exciting possibilities open up when using white "not" watercolor paper, or slightly textured "rough" watercolor paper. It can be tinted any color or combination of colors, using watercolors or acrylic paint. Suitable white watercolor paper,

NOT watercolor paper

ROUGH watercolor paper

Cotman or Winsor & Newton artist quality paper can be bought by the sheet or in sketch pad form.

Cut a sheet of the paper to the size you want. Using a strong tape, stick all four sides of the paper to a wooden drawing board. Use a large flat watercolor brush to apply a wash of water color or acrylic paint of your choice to the paper. Let it dry naturally, or accelerate the drying by using a hand-held hair dryer to blow warm air on the paper to evaporate the water. Any wavering of the paper should go as it normally dries flat.

Tinting watercolor paper for pastels

PERSPECTIVE

Perspective is the one area of drawing and painting in which most people experience some degree of difficulty. The secret is to keep the whole business of perspective as simple as possible, to remember a few basic rules, and to bear in mind that perspective is not something one masters all in a few lessons. Learning about perspective is an ongoing process. One goes along over a period of months, indeed years, collecting together the pieces of information, like pieces of a jigsaw, until they all fit together and the picture, the theory of perspective, becomes clear and easy to apply to one's work.

The eye level (EL) is an imaginary line, horizontally across your field of vision when you look straight ahead; not up, nor down, but straight ahead.

In figure 1, a figure is shown sitting low down, as if on a beach, then standing, then standing on a sand dune. Note how the eye level is always directly ahead of the figure.

When looking at a real subject, look straight ahead, hold a ruler straight out with the thin edge in front of you, and across your eyes, and that is where your eye level is. Which comes first, the drawing in of the eye level or the object? Draw in the object lightly first, then apply the eye level and use it with the rules of perspective to check and correct the object. One way to see perspective in action is to picture the view looking along railway lines. They appear to merge in the distance.

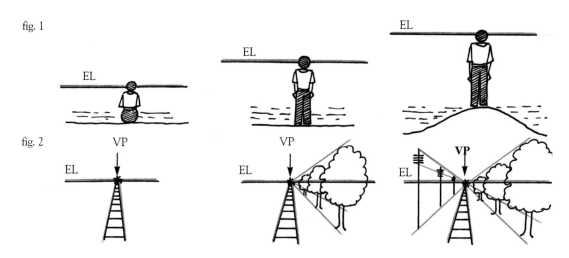

fig. 1

fig. 2

They appear to become smaller and closer together. The point where they appear to merge is known as the vanishing point (VP). We know they do not merge in reality. In figure 2, the railway lines with telegraph poles are on the left, and three trees on the right. The telegraph poles and the trees in a drawing or painting would also appear to become smaller and closer together as they recede.

The guidelines in each illustration show how the items meet at the vanishing point.

Guidelines will often converge at vanishing points off the page. When this happens, lay scrap paper at the side and tape it on from behind, then extend the guidelines onto it, as shown in the sketch. Never guess or assume the perspective is correct, always try to prove it.

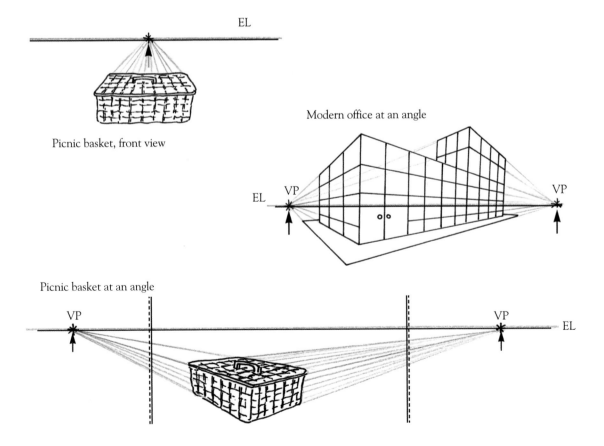

EL

Picnic basket, front view

Modern office at an angle

EL VP VP

Picnic basket at an angle

VP VP EL

Circular Perspective

Few people realize that perspective helps to solve the problems of drawing circles and ellipses, but it can. This is illustrated in a sketch of kitchen utensils below. The group is lightly drawn out and eye level is well above it. A light guiding square is drawn around each ellipse. The squares for the ellipses each have their respective vanishing points on the common eye level. The use of the squares helps determine where each vanishing point should be, to ensure the true perspective of the subject where there is an ellipse involved. Go back to each ellipse and check if it touches the center of each side of the square it occupies. If it does, the ellipse is in perspective. Gently rub out the squares used outside of each ellipse and perspective guidelines before a picture is shaded in or painted.

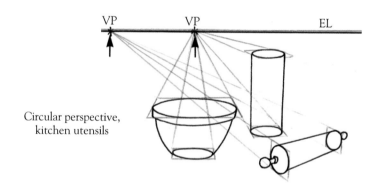

Circular perspective, kitchen utensils

COMPOSITION

There are certain guidelines that, if followed, can help you build your work on sound compositional foundations. One of the most important things to avoid is having any line or object that cuts your picture into two equal halves. Set any such line or object to one side or other.

Focal Points and Key Lines
Decide what it is that you want the viewer to look at. Ensure their eyes will not wander by being decisive about the focal point of the picture.

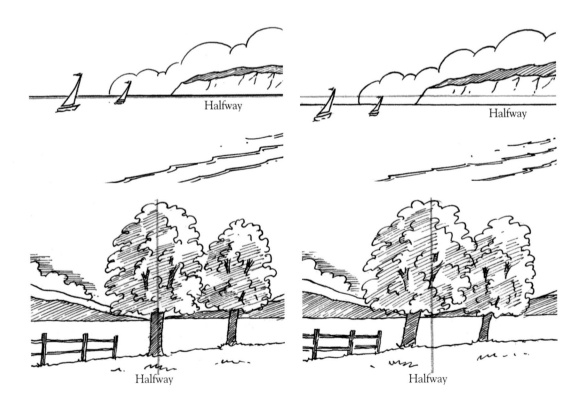

Every picture should have a main feature to which the eye instinctively goes. Here there are three views. In one, the focal point, the village (fig. 1), is in the middle distance. In the second, the focal point, the sailboat (fig. 2), is in the far distance. In the third, the man standing on the pier (fig. 3) in the foreground is the focal point. A picture should also have key lines of the composition leading the eyes of the viewer to the focal point. The key lines of the three compositions are arrowed, illustrating how the use of the focal point helps bring a composition together.

fig. 1

fig. 2

fig. 3

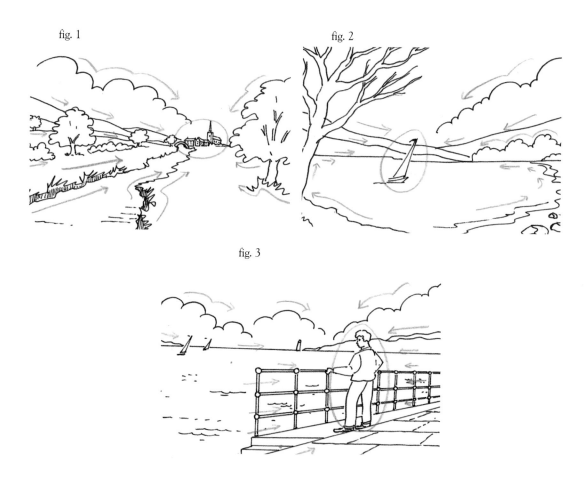

The Triangle

Often a triangle can offer an excellent shape on which to base a composition, especially a still life or floral study. Here is a still life made up from a bowl of fruit. The pineapple is placed to the right so the apex of the triangle is off-center. The daffodil in the vase forms the upright of the triangle, with the magazine forming the base. The man creates the triangle's upright side, with the table and floor forming the bottom and third, sloping side, of the triangle. Try to ensure that still life and floral studies have height, width and depth to them. If you now go and look at paintings, or prints of paintings, by any of the great masters, or by any fine artist, you will almost certainly find that their most successful paintings employ many of the important compositional points referred to here.

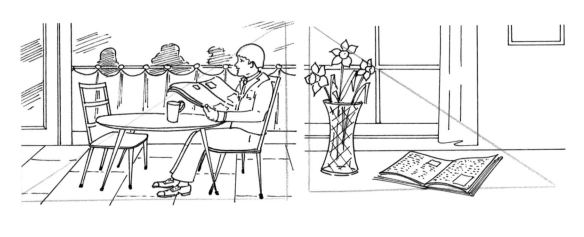

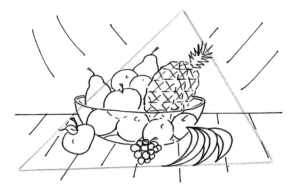

PASTEL PENCILS

Pastel pencils are a very popular way of creating pastel pictures. The pastel comes encased in wood and has a presharpened point. They are especially suitable for work in which detail is important. They can also be combined with the soft pastels used in the previous sections of this book. Apart from the facility to create detail easily, your fingers will generally remain clean due to the pastels' wooden casing.

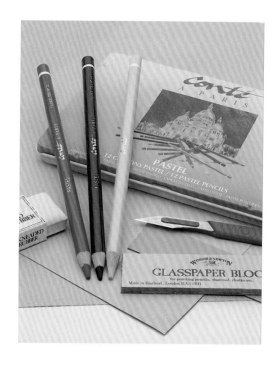

As with all art materials it is important to spend a little time playing with the pastel pencils to see just what effects can be created. Pick up a pastel pencil and try creating the lines and effects you see in the bottom right-hand panel. Try hatching lines, crosshatching, stippling and traditional shading effects working from light to dark.

Note and try the different hatching and crosshatching effects for the colored balls (page 48). Draw the outline of the box, then draw it again and shade it in. Make experimental shading strips, superimposing one color on another. Note how subtle color changes can be made as the colors overlap. Try creating the tile, brick and tree effects. Try creating the fish silhouettes and face just by using downward hatching lines. Experimenting in this way will be time well and wisely spent.

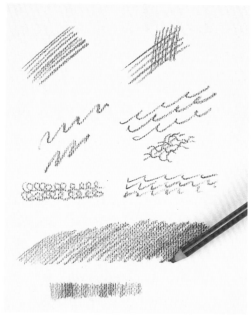

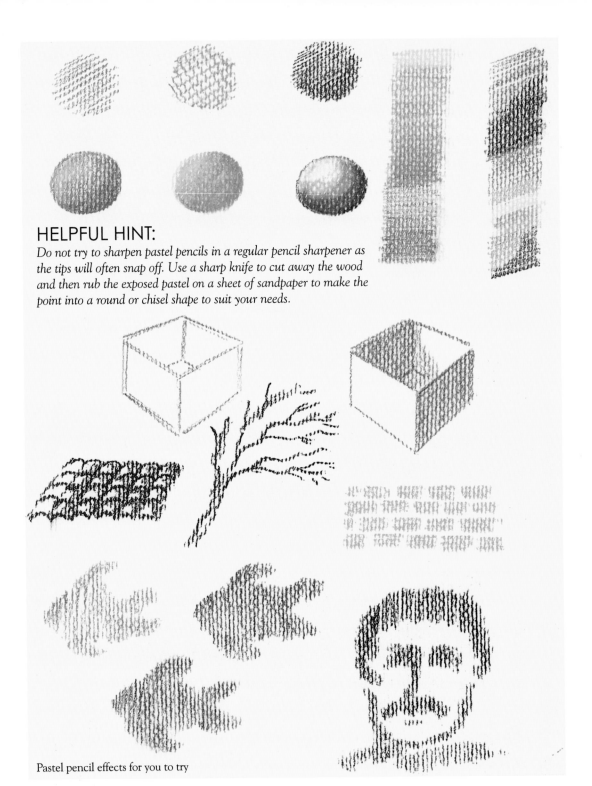

HELPFUL HINT:

Do not try to sharpen pastel pencils in a regular pencil sharpener as the tips will often snap off. Use a sharp knife to cut away the wood and then rub the exposed pastel on a sheet of sandpaper to make the point into a round or chisel shape to suit your needs.

Pastel pencil effects for you to try

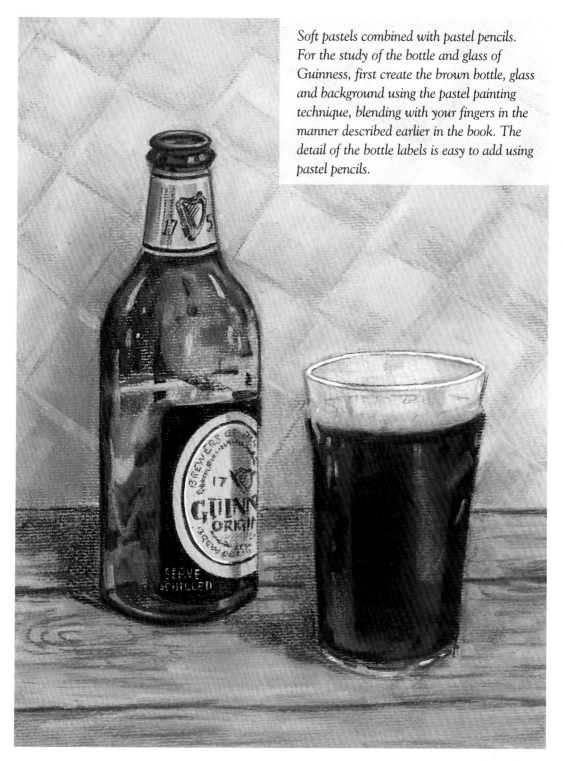

Soft pastels combined with pastel pencils. For the study of the bottle and glass of Guinness, first create the brown bottle, glass and background using the pastel painting technique, blending with your fingers in the manner described earlier in the book. The detail of the bottle labels is easy to add using pastel pencils.

PORTRAIT

The ability to use the sketching or pastel painting technique makes pastels an excellent medium for portraiture. The main blocks of color for the face and hair can be created by blending the colors, and pastel pencils make the addition of details such as the eyes, nose, ears and mouth quite easy.

Stage 1. For the study of the young man, sketch the outline in white pastel pencil. Then use generous amounts of red, yellow ochre and white pastel pencils on the face and neck. Likewise apply light and dark brown to the hair in the way shown.

Stage 2. Blend the pastel strokes of the face and neck with a finger. Shadows to the flesh can be added by superimposing a little strong deep green and gently blending that into the flesh color to create deeper flesh tones. With a clean finger blend the colors of the hair.

Stage 3. Use the pastel pencils to pick out the detail of the eyes, detail and shadow of the nose, nostril and the lips. The top lip is always a darker tone of red, with the highlight on the lower lip because that usually catches the light. The lines and contours of the hair can now be added, applying the lighter lines first, then the darker lines.

Stage 4. Add the shirt collar and jacket collar using a blending technique. Use an incomplete sketched look for the rest of the jacket. This will keep the emphasis on the main part of the picture, the face.

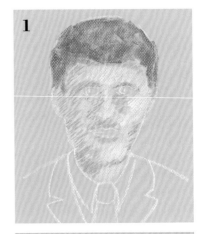

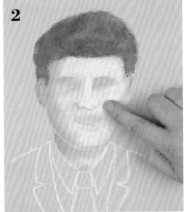

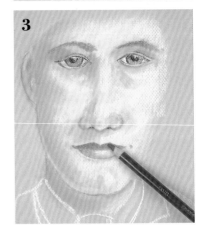

4

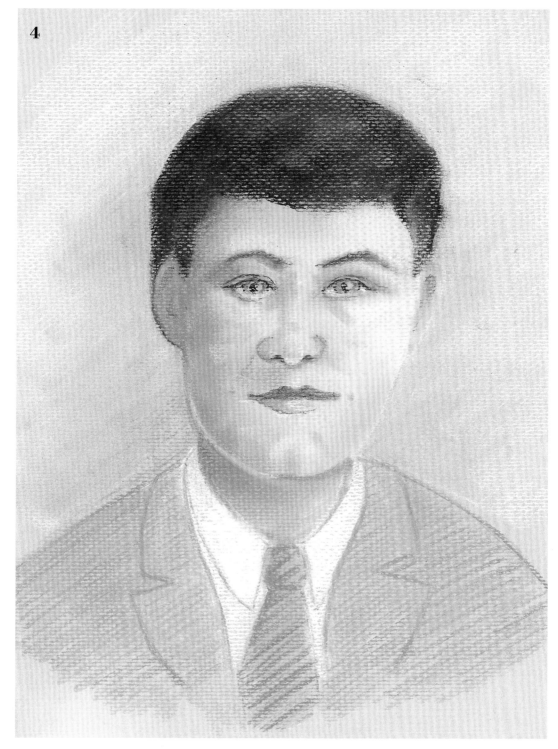

A BIRD

The pastel painting technique was used for this study. Much more of the pastel than usual was applied to each area of the picture, using the pastel pencil to blend the top color into the bottom color. A finger, a tortillon or a stub can also be used for blending. The essential detail was picked out at the end using resharpened pastel pencils.

Stage 1. Draw the bird in white pastel. Start to pastel in the main areas of color.

Stage 2. Look at each area and use darker pastel tones to build up the deeper, darker areas. Use white on the lighter areas, still blending each area to create the lighter and darker tones for the head and body of the bird.

Stage 3. The pastel pencils now enable you to draw in the detail to the eye, beak, feathers and the pattern on the body. The detail on the webbed feet can be added with black pastel pencil.

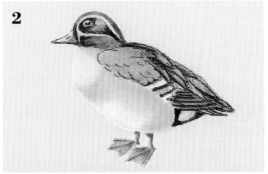

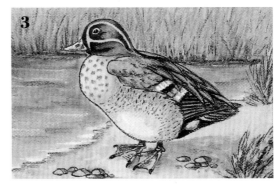

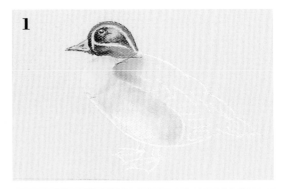

OIL PASTELS

Oil pastels are very different from chalk pastels and pastel pencils. Because they are oil based, they will not mix with soft pastels. They are normally used on their own and have quite different properties to chalk pastels. Most art shops stock oil pastels, usually in sets, but sometimes they can be purchased loose as individual colors.

Both oil and chalk pastels can be used in stick form to draw lines, or to shade in larger areas of color. They can be superimposed on top of one another to create color mixtures and blended effects. Red on yellow will create orange, blue on yellow will create green. They can also be blended with a soft sable or synthetic hair brush and turpentine. The artist dips the brush in a little clean turpentine and brushes over the area of oil pastel on the paper to dissolve the paint and blend it, or move it around, in a semi-fluid state to achieve different effects.

While oil pastels can be used on canvas or canvas board, they work best on normal thick cartridge paper. If using turpentine to blend them, a colorless damp stain appears on the paper. This disappears as the turpentine evaporates from the paper. Try the dry oil pastel lines and effects and then the blended effects shown in the right-hand panels.

Lines and effects

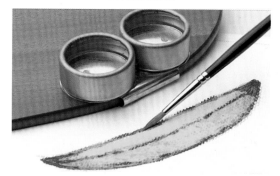

Blending with turpentine and a brush

With the banana in the first panel, the dry pastel sketching technique was used. The second panel features the brush-blended technique. Trying these exercises will introduce you to the key techniques of oil pastels which you can try in other subjects. Start with yellow, then add a little green for the shadow and the black for the ends and marks on the skin.

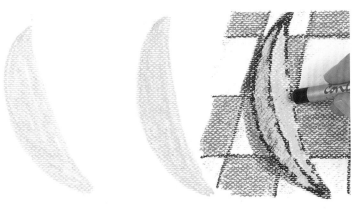

1. Yellow

2. Green added for shadow

3. Black tips and skin marks added

HELPFUL HINT:

If using a brush for blending, when finished wash the hairs with warm soapy water, cleaning them thoroughly, then shake the brush dry. Stand it upright in a jar to enable the hairs to dry completely.

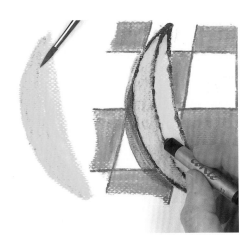

1. Yellow

2. Green added for shadow

Banana blended with turpentine and brush

3. Black tips and skin marks added and also blended with turpentine and a brush

FIXING AND FRAMING PASTELS

To prevent soft pastel and pastel pencil pictures from smudging it's a good idea to give each picture a light spray of pastel fixative. Clear fixative is obtainable in aerosol cans from art stores. Do not use this on oil pastels.

Lay newspaper on a table in a well-ventilated room. Hold the can of fixative 18" (45 cm) above the picture and lightly spray it from left to right, top to bottom. Do not over-spray the picture. Any slight dampness will go as the fixative evaporates. A sheet of acid-free, greaseproof paper can be laid over a dry pastel picture and held in place with paperclips in each corner. This prevents the transfer of color to the backs of other pictures. The finished work can be stored flat in a portfolio.

While some people like to make their own frames, most people take them to a professional picture framer. Pastels are best framed in the same manner as a watercolor. Select a complementary color of mount and a suitable frame moulding. A good framer will help and advise you if you ask. The window mount provides a border round the picture and an air-space so the glass does not sit on the surface of the picture. A sheet of hardboard is used for the back and the assembled picture is ready for you to hang.

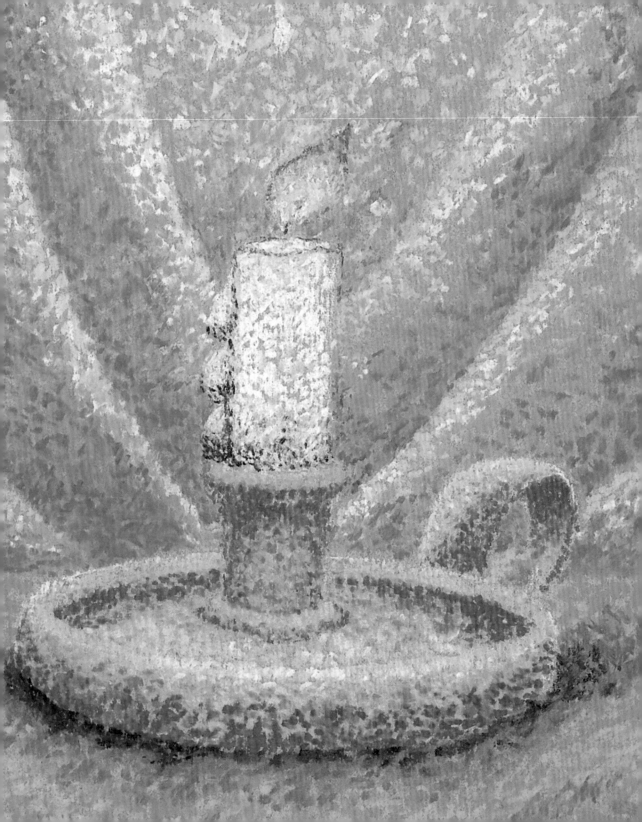

LESSONS

LESSON 1:
A SUNSET

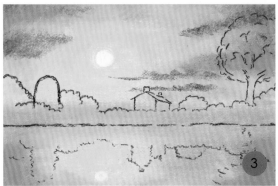

The fiery evening sunset takes us into a brighter, vivid range of pastel colors. The subject allows you to practice pastel blending, yet offers the use of a silhouette for detail and contrast between light and dark.

Step 1: Create the sunset and reflection in the water first. Use white pastel for the sun, yellow and orange in the remaining areas, with just a little crimson red in all four corners of the page.

Step 2: Blend the colors with your fingertip, working from light to dark: white to yellow to orange to red.

Step 3: Use the top edge of a black pastel or black pastel pencil to lightly draw on the real and reflected body of the windmill, house, tree and bushes.

Step 4: With a pointed black pastel or black pastel pencil and a ruler, draw in the windmill sails. A little yellow can be used for highlights and also for the windows on the house. Using dark brown pastel and a black pointed pastel, pick out the boughs and branches of the tree.

Use orange for the highlights on the tree. Complete the reflections with horizontal strokes of the pastel to add to the watery effect.

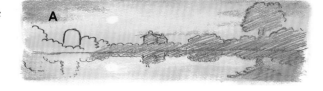
Details:

A. In the shapes created by the outline use diagonal strokes of brown pastel to fill in the silhouette in the sky and its reflection in the river.

B. Press more heavily on the brown pastel.

C. Use gentle black diagonal lines over the brown, blending with the tip of a finger or if you wish, leaving it unblended in these areas.

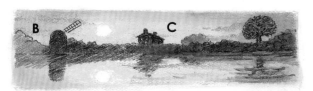

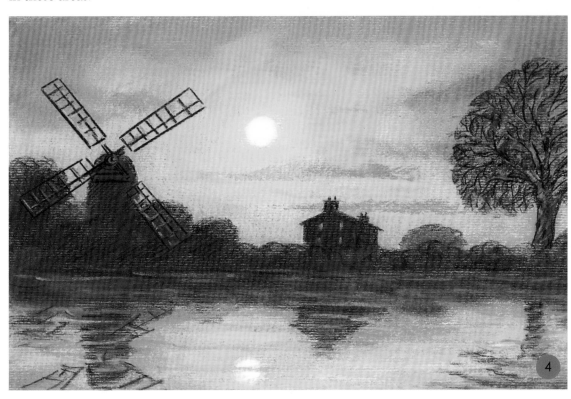

LESSON 2: BRIDGE OVER RIVER

HELPFUL HINT:

To help capture feeling in your picture, try to imagine what it would look like, sound and feel like standing on the riverbank.

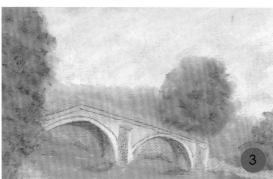

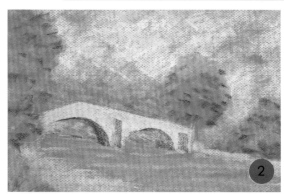

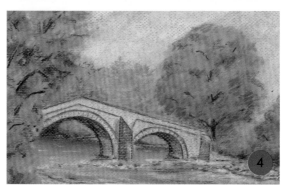

Much in nature is based on curved lines, circles and ovals, but so much of what man builds is based on straight lines. This subject combines straight and curved lines.

Step 1: Sketch the outline of the subject in white.

Step 2: Fill in the main blocks of color for each area. Be generous with the amount of pastel you use. With the pastel painting technique you really have to be prepared to use a substantial amount of pastel, especially the lighter colors.

Step 3: Rub and blend the main areas of pastel so that all the paper is fully covered.

Step 4: This is where you start to look for and develop the essential features and details: add stronger blue to sky and water, add the shadows under the bridge arches, the dark greens and highlights on the foliage, the highlights on the water, the foreground stones and rocks in the river.

LESSON 3: BREAD AND CHEESE

HELPFUL HINT:
Use pastel pencils and the hatching technique to add detail to this sketch more easily.

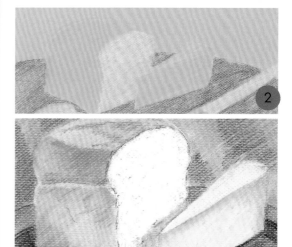

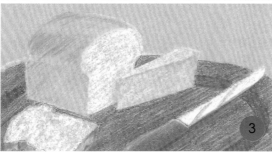

A cut loaf, a piece of cheese and a bread knife are yet another example of how you can create interesting subjects by just looking around your home.

Step 1: On a sheet of light gray pastel paper sketch out the subject in white pastel pencil.

Step 2: Using a light, creamy beige for the outer bread crust build up diagonal hatching lines. The strength of tone of color is controlled by the pressure you apply to the pastel. The heavier the pressure, the stronger the color. The less the pressure, the softer the color. Use the same method for the crust of the slice of bread. Use the light, creamy beige pastel for the cheese. Hatch in the brown breadboard and knife still using diagonal hatching lines.

Step 3: Using a burnt sienna, a reddish-brown pastel pencil, superimpose the warmer tones on the bread crust. Use a combination of gentle light brown and gray strokes to create the shadow side of the cheese. Superimpose darker brown lines on areas of the breadboard, with gentle black lines added on top of the shadows. Use a little gray on parts of the bread. Also use this technique for the slice of bread and the knife.

Step 4: Pay special attention to the texture of the bread crust and white bread areas and the detail on the knife. Do not forget to add the dark shadow under the front edge of the breadboard and the white flashes of highlight on the bread knife.

LESSON 4: BALLET DANCER

HELPFUL HINT:
Use white highlights to make skin glow. A bit of blue on top of the skirt will also look interesting.

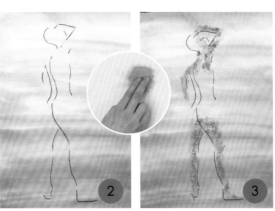

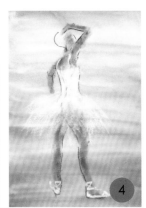

This graceful figure looks lovely in pastels over a dreamy watercolor background.

Step 1: Dampen your paper and make a wet-into-wet watercolor wash over the whole page using blues and violets.

Step 2: Lightly sketch the figure in black. The head should be an eighth of the total body height.

Step 3: Using the side of your pastels, very lightly block in the flesh. First use yellow, then put red on top. Blend lightly with your fingers. Make the leg color go right up to the top of the thigh.

Step 4: Press hard with white for the dress bodice and shoes. Then use the side of the pastel for a light net skirt over the top of the legs. Let the legs show through.

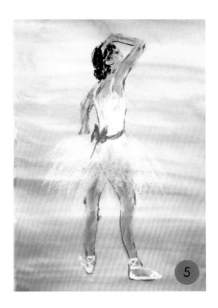

Step 5: Use black for hair. Draw in a bun, but leave space for the hand and ear. Use the edge of your red pastel to make firm strokes for a bow and ribbon around the waist. Add a few dark lines to define arms and legs.

LESSON 5: SUNFLOWERS

HELPFUL HINT:
Use fixative spray over your picture to stop smudging. You can still work on top of it.

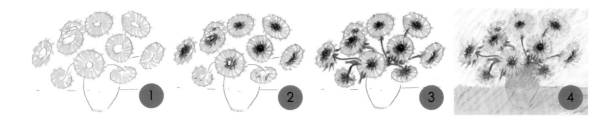

Van Gogh's *Sunflowers* is one of the most popular paintings in the world. You can make your own version in vivid pastels to brighten up your wall.

Step 1: Lightly sketch the vase and flowers in brown. Note how some flower heads are ellipses, not circles. Make strong yellow petals, fanning out from the center and going over the brown.

Step 2: Add brown and red to some centers and petals; add black to some centers, too.

Step 3: To make green for stems and flower backs, draw first with blue, then go over with yellow.

Step 4: With the side of your pastel, put yellow in the background, add white and smudge together. Then do the same on the table and vase with brown and yellow.

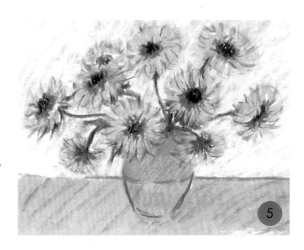

Step 5: Hatch lines to build up color on the picture. Add a light blue line around the vase and tabletop (like Van Gogh did on some of his paintings) and see how the blue makes the yellow look bright.

Make petals stand out from the page with extra yellow, brown and red.

LESSON 3:
CAT ON A CUSHION

HELPFUL HINT:
Use free strokes to follow contours of cat and cushion as shown. It will help define their shapes.

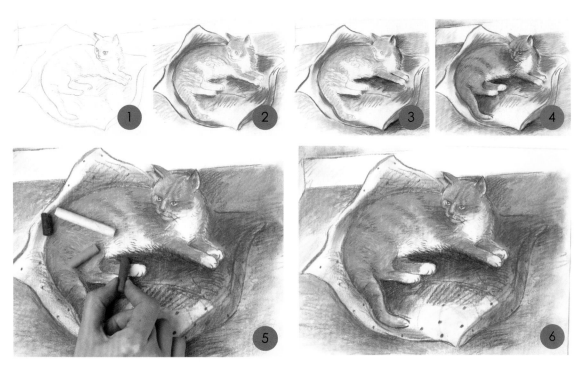

What could make a nicer subject than your own lovely cat?

Step 1: Sketch pose in pencil. Keep lines light so they won't show later.

Step 2: Color main areas with blue, light blue, and yellows. Leave white areas and smudge colors with your fingertips to soften and blend them.

Step 3: Add shadows around the body and under the cushion by hatching with red and black.

Step 4: Continue to make shadows by hatching and smudging with red, blue and black. Add detail to the cat's face and markings on her body with red, yellow ochre, black and white.

Step 5: Make the fur look thick and textured with blended and unblended strokes of charcoal and white. Brighten the eyes with white.